Draw 50 Sea Creatures

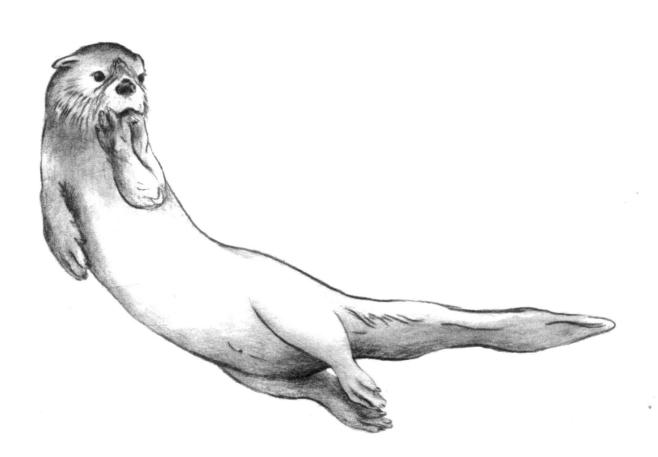

. 1

Sea Creatures

THE STEP-BY-STEP WAY TO DRAW
Fish, Sharks, Mollusks, Dolphins, and More

LEE J. AMES with Erin Harvey

CONTENTS

TO THE READER 7

TO THE PARENT OR TEACHER 9

SEA FAN 10

BURROWING TUBE ANEMONE 11

BRANCHING CORAL 12

BLADE CORAL 13

KELP 14

FEATHER STAR 15

SEA URCHIN 16

SEA NETTLE JELLYFISH 17

SEA HORSE 18

WEEDY SEADRAGON 19

SHRIMP 20

BLUE CLAW CRAB 21

NAUTILUS 22

CONCH SHELL 23

GIANT CLAM 24

OYSTER 25

HARBOR SEAL 26

WALRUS 27

AFRICAN PENGUIN 28

PUFFIN 29

PELICAN 30

SEA OTTER 31

NARWHAL 32

HUMPBACK WHALE 33

BOTTLENOSE DOLPHIN 34

LEATHERBACK SEA TURTLE 35

PACIFIC HALIBUT 36

SOCKEYE SALMON 37

STRIPED SURGEONFISH 38

REGAL TANG 39

CLOWN TRIGGERFISH 40

CLOWNFISH 41

MOORISH IDOL 42

CARDINALFISH 43

COPPERBAND BUTTERFLYFISH 44

LIONFISH 45

HANDFISH 46

HAWAIIAN SQUIRRELFISH 47

GOLIATH GROUPER 48

BALLOONFISH 49

SAILFISH 50

ANGLERFISH 51

GULPER EEL 52

BASKING SHARK 53

WHALE SHARK 54

BLACKTIP REEF SHARK 55

GHOST SHARK 56

SAWSHARK 57

SOUTHERN STINGRAY 58

BLUE-RINGED OCTOPUS 59

ABOUT THE AUTHOR AND

ILLUSTRATOR 61

TO THE READER

This book will show you a way to draw sea creatures. You need not start with the first illustration. Choose whichever you wish. When you have decided, follow the step-by-step method shown. Very lightly and carefully, sketch out the first step. However, this step, which is the easiest, should be done most carefully. The next step is added right to the first one, also lightly and also very carefully. The thrid step is sketched right over numbers one and two. Continue this way to the last step.

It may seem strange to ask you to be extra careful when you are drawing what seem to be the easiest first steps, but these are the most important, for a careless mistake at the beginning may spoil the whole picture at the end. As you sketch out each step, watch the spaces between the lines, as well as the lines, and see that they are accurate. After each step, you may want to lighten previous steps by pressing it with a kneaded eraser (available at art supply stores).

When you have finished, you may want to redo the final step in India ink with a fine brush or pen. When the ink is dry, use the kneaded eraser to clean off the pencil lines. The eraser will not affect the India ink.

Here are some suggestions: In the first few steps, even when all seems quite correct, you might do well to hold your work up to a mirror. Sometimes the mirror shows that you've twisted the drawing off to one side without being aware of it. At first you may find it difficult to draw the egg shapes, or ball shapes, or sausage shapes, or to just make the pencil go where you wish. Don't be discouraged. The more you practice, the more control you will develop.

The only equipment you'll need will be a medium or soft pencil, paper, a kneaded eraser, and, if you wish, a pen or brush and ink.

The first steps in this book are shown darker than necessary so that they can be clearly seen. (Keep your work very light.)

Remember there are many other ways and methods to make drawings. This book shows just one method. Why don't you seek out other ways from teachers, from libraries, and—most important—from inside yourself?

-Lee J. Ames

TO THE PARENT OR TEACHER

"David can draw a jet plane better than anybody else!" Such peer acclaim and encouragement generate incentive. Contemporary methods of art instruction (freedom of expression, experimentation, self-evaluation of competence and growth) provide a vigorous, fresh-air approach for which we must all be grateful.

New ideas need not, however, totally exclude the old. One such is the "follow me, step by step" approach. In my young learning days, this method was so common, and frequently so exclusive, that the student became nothing more than a pantographic extension of the teacher. In those days it was excessively overworked.

This does not mean that the young hand is never to be guided. Rather, specific guiding is fundamental. Step-by-step guiding that produces satisfactory results is valuable even when the means of accomplishment are not fully understood by the student.

The novice with a musical instrument is frequently taught to play simple melodies as quickly as possible, well before he learns the most elemental scratchings at the surface of music theory. The resultant self-satisfaction and pride in accomplishment can be a significant means of providing motivation. And all from mimicking an instructor's "Do as I do...."

Mimicry is a prerequisite for developing creativity. We learn the use of our tools by mimicry. Then we can use those tools for creativity. To this end I would offer the budding artist the opportunity to memorize or mimic (rotelike, if you wish) the making of "pictures." "Pictures" he or she has been anxious to draw.

The use of this book should in no way be compulsory. Rather it should be available to anyone who wants to try another way of flapping his wings. Perhaps he will then get off the ground when his friend says, "David can draw a jet plane better than anybody else!"

-Lee J. Ames

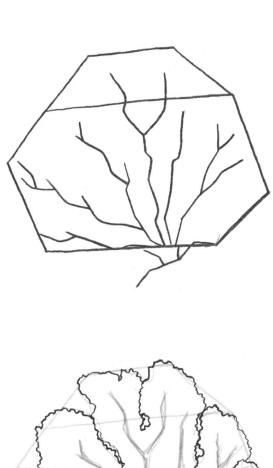

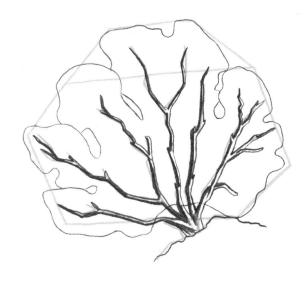

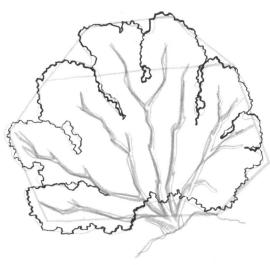

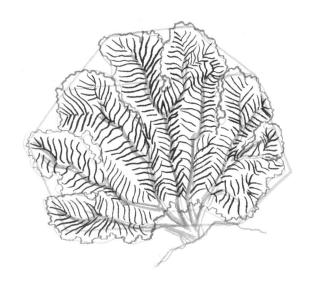

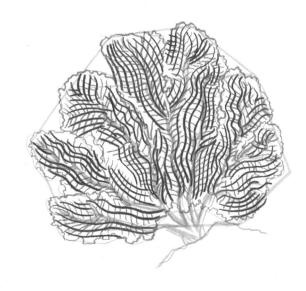

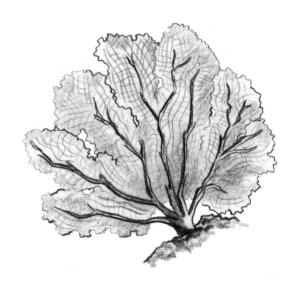

BURROWING TUBE ANEMONE

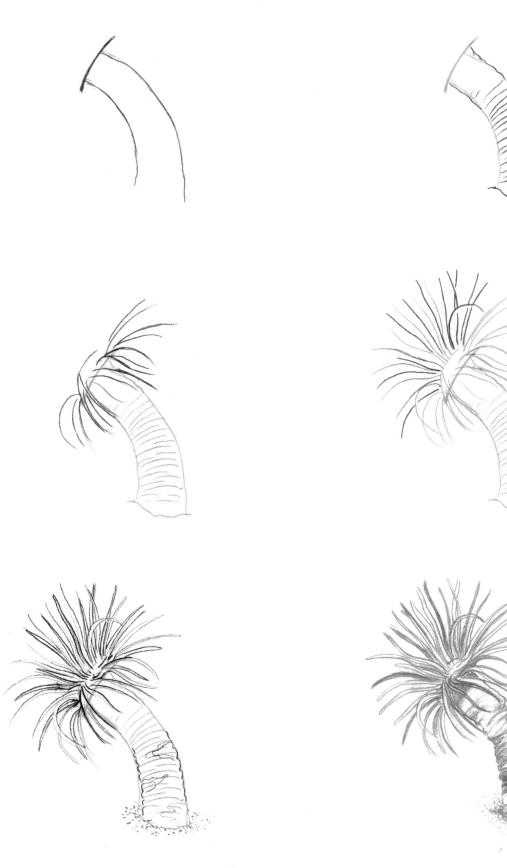

BRANCHING CORAL

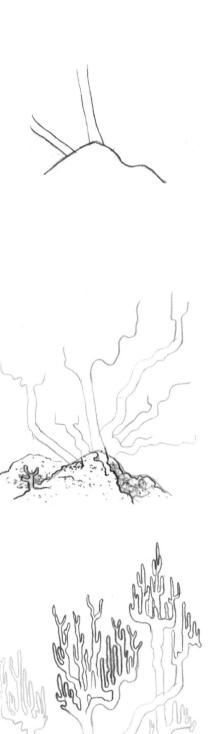

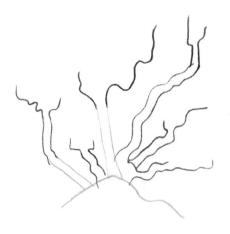

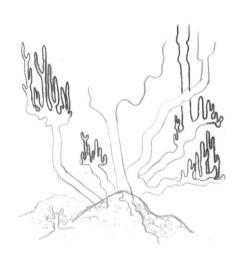

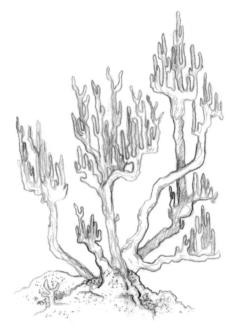

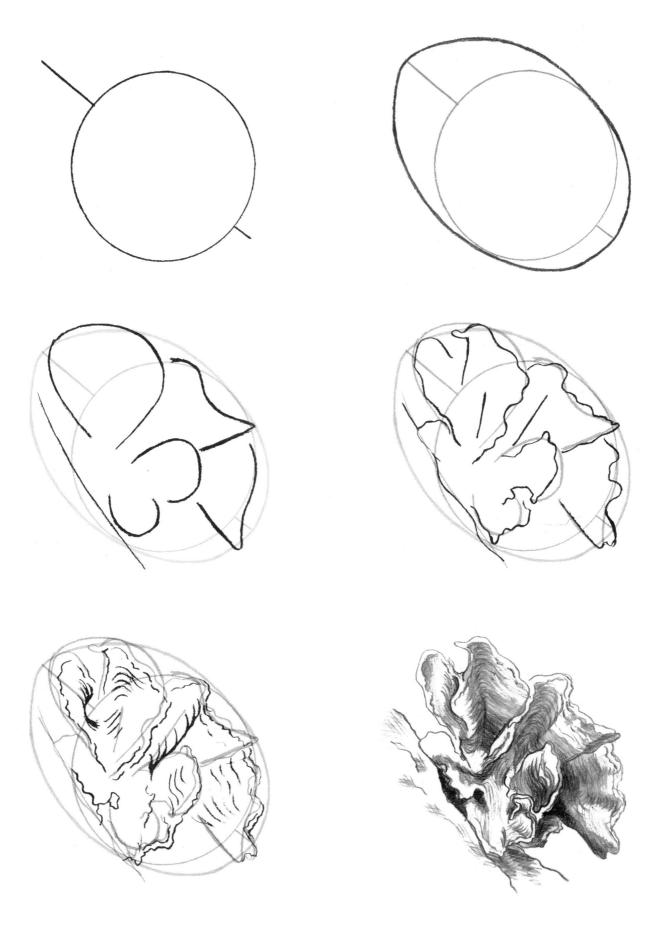

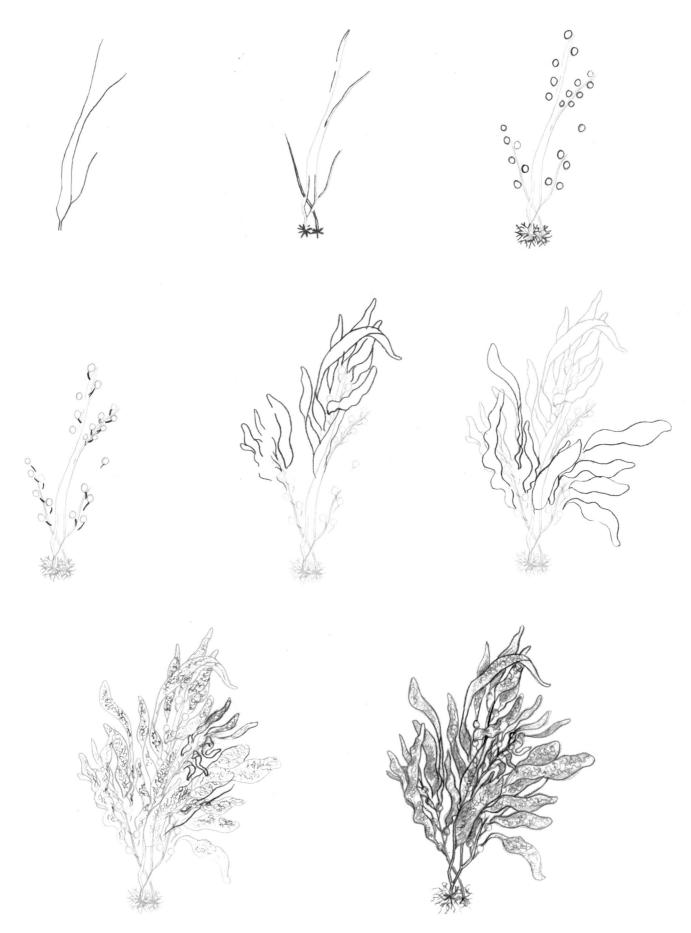

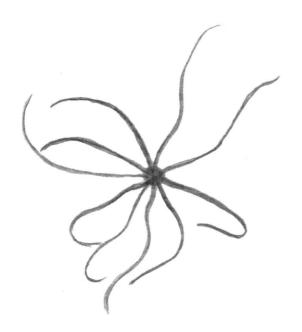

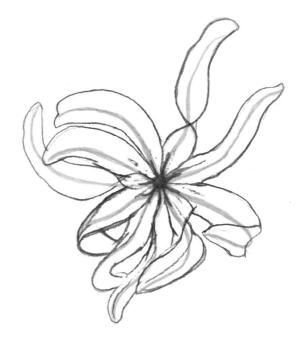

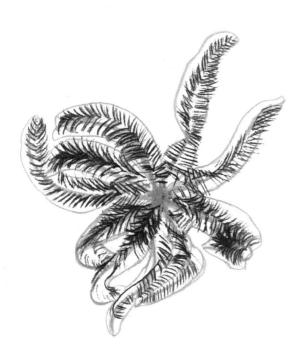

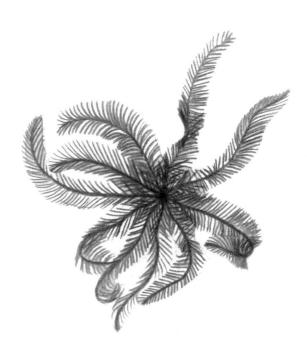

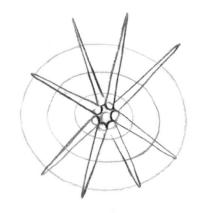

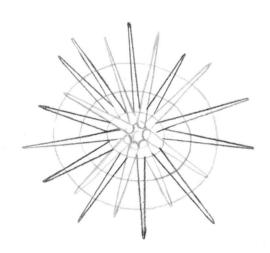

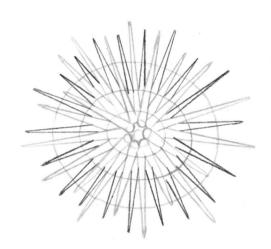

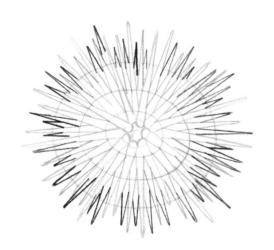

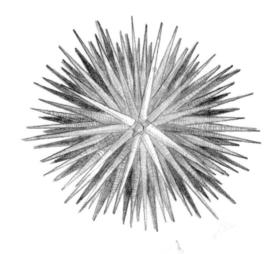

SEA NETTLE JELLYFISH

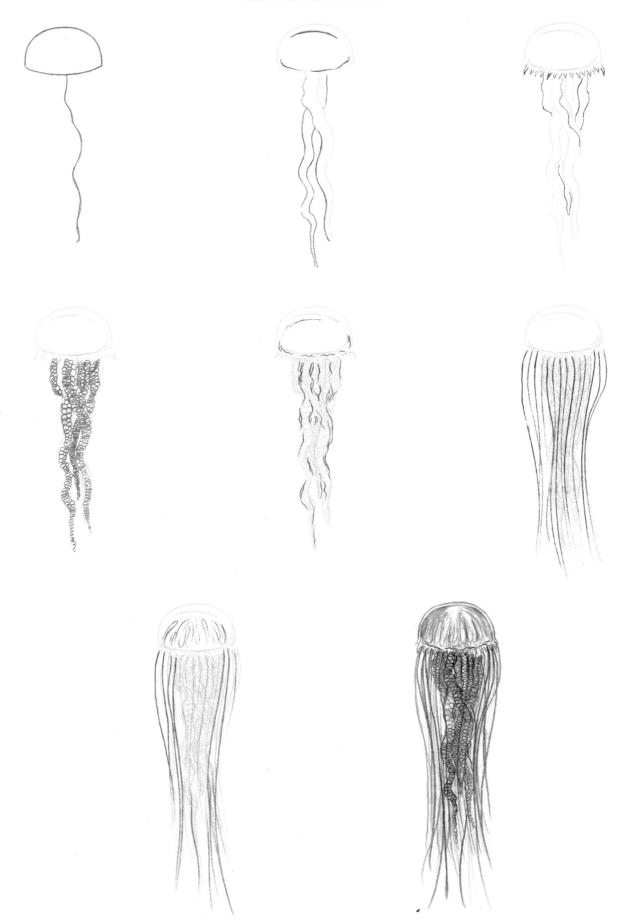

SEA HORSE

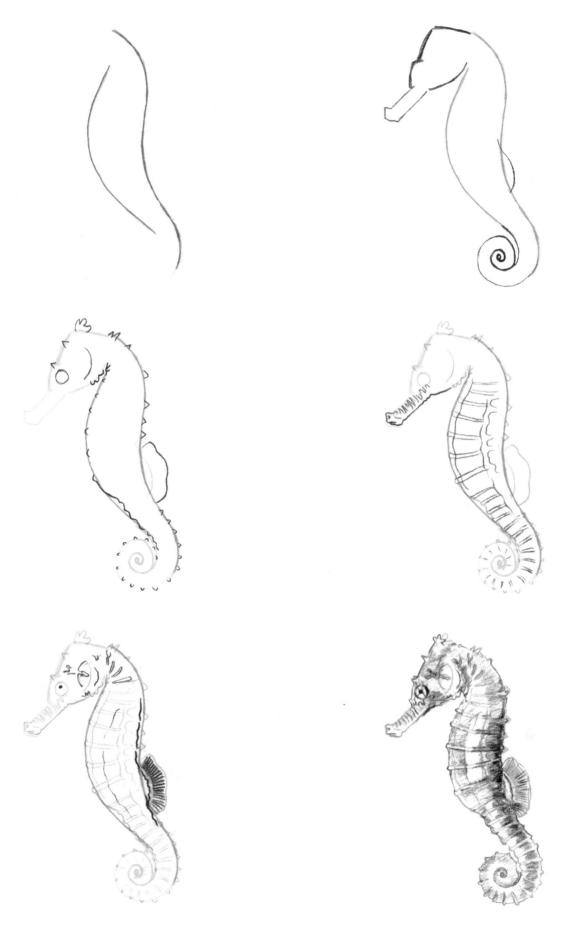

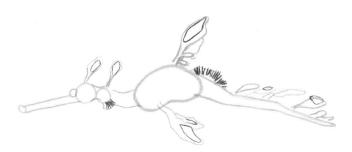

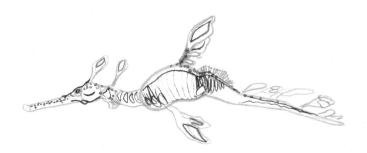

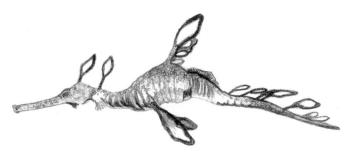

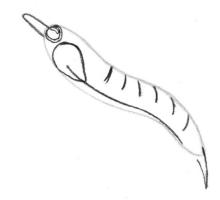

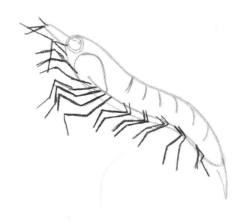

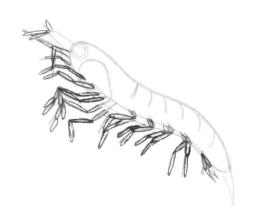

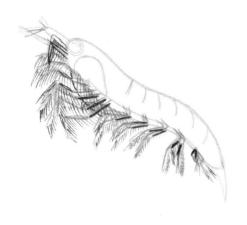

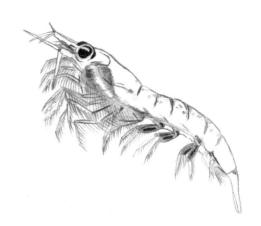

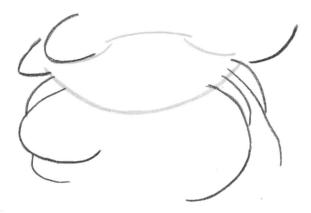

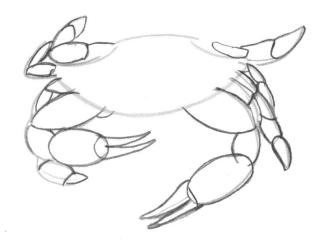

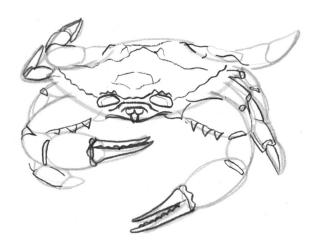

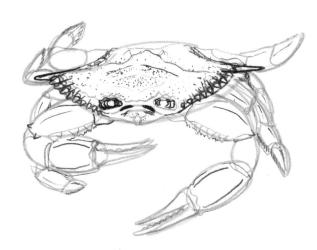

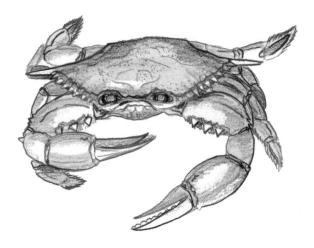

NAUTILUS

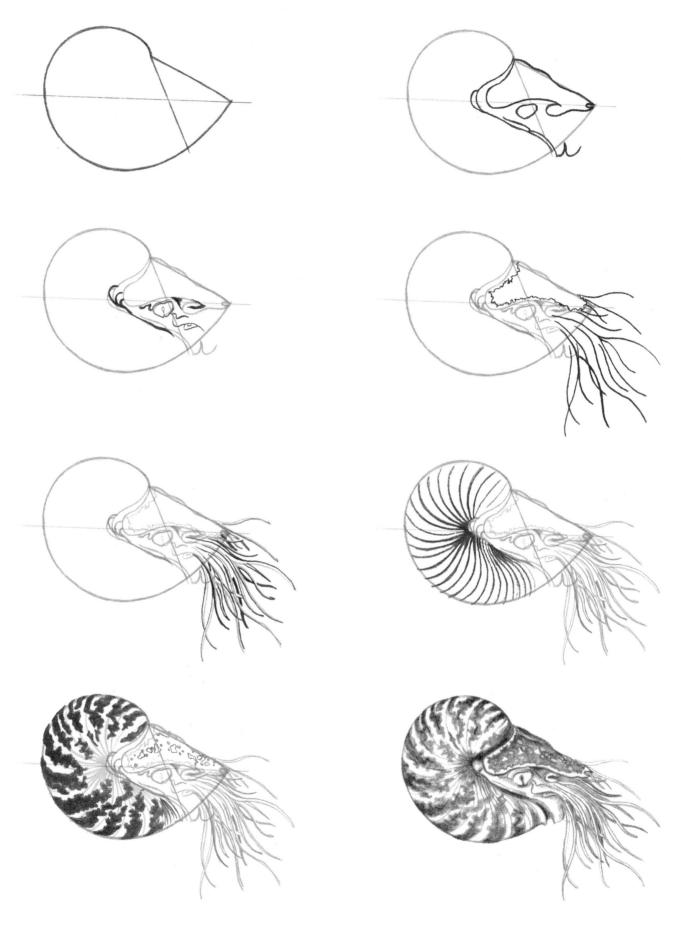

CONCH SHELL

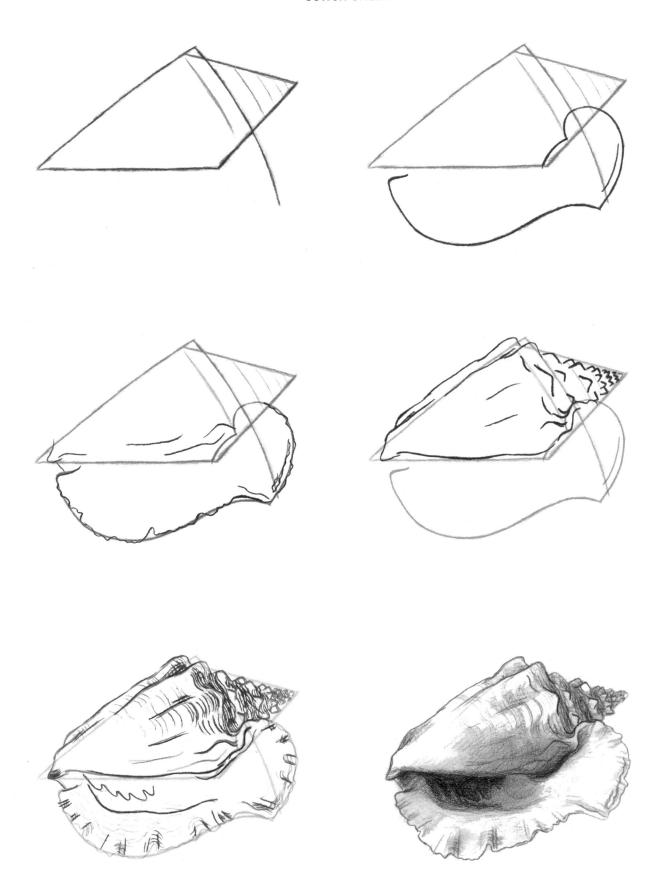

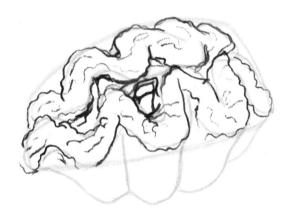

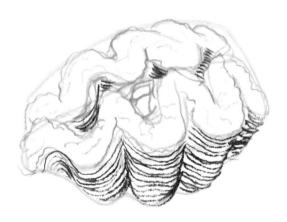

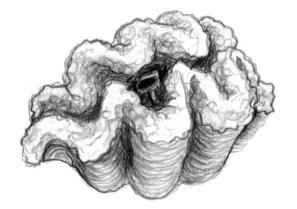

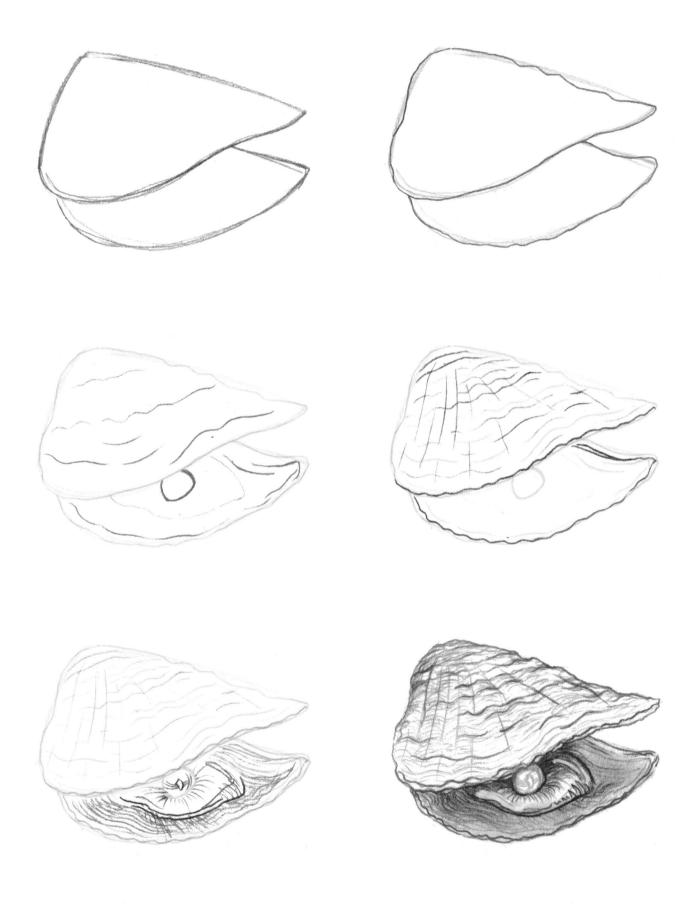

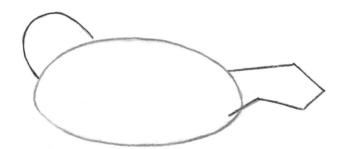

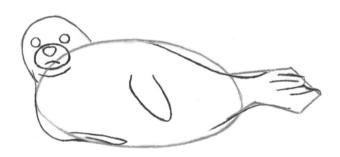

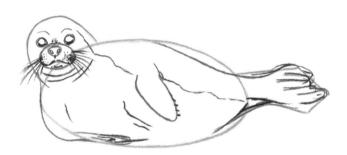

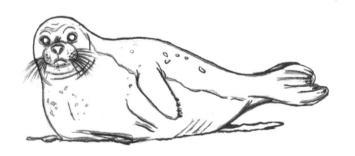

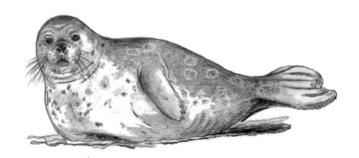

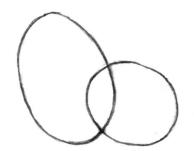

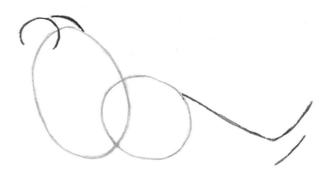

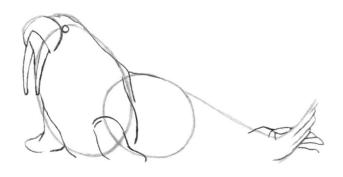

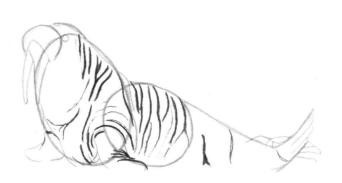

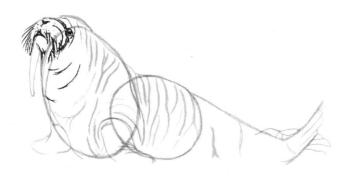

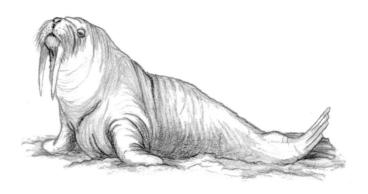

AFRICAN PENGUIN

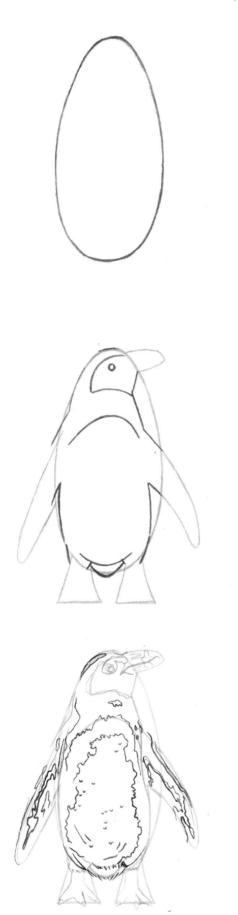

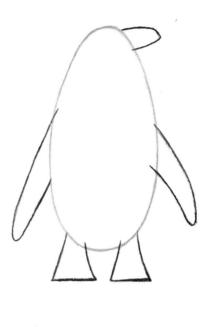

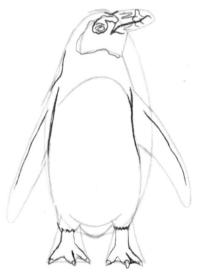

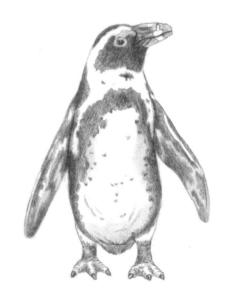

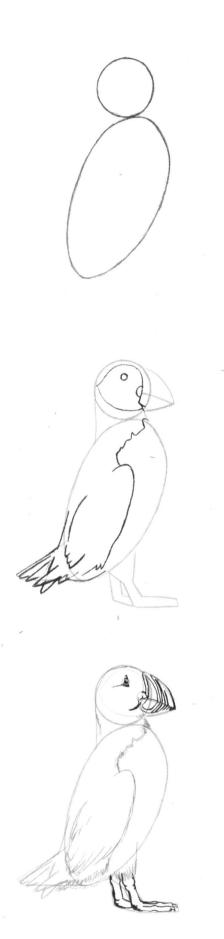

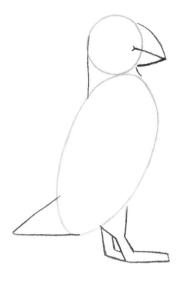

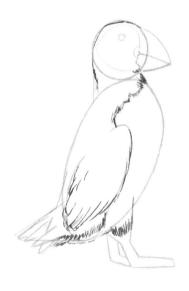

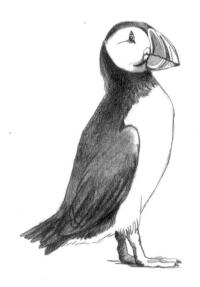

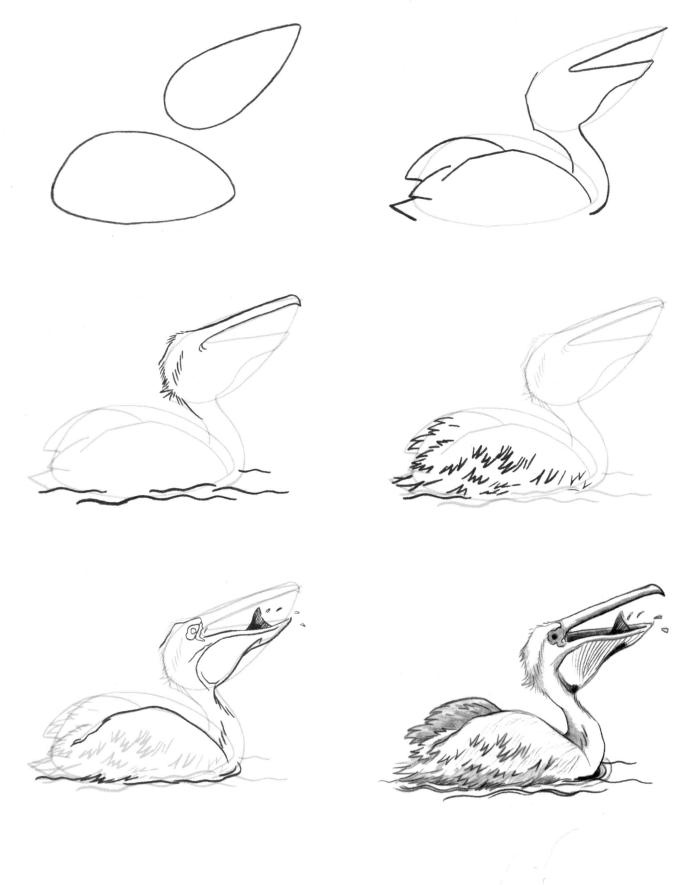

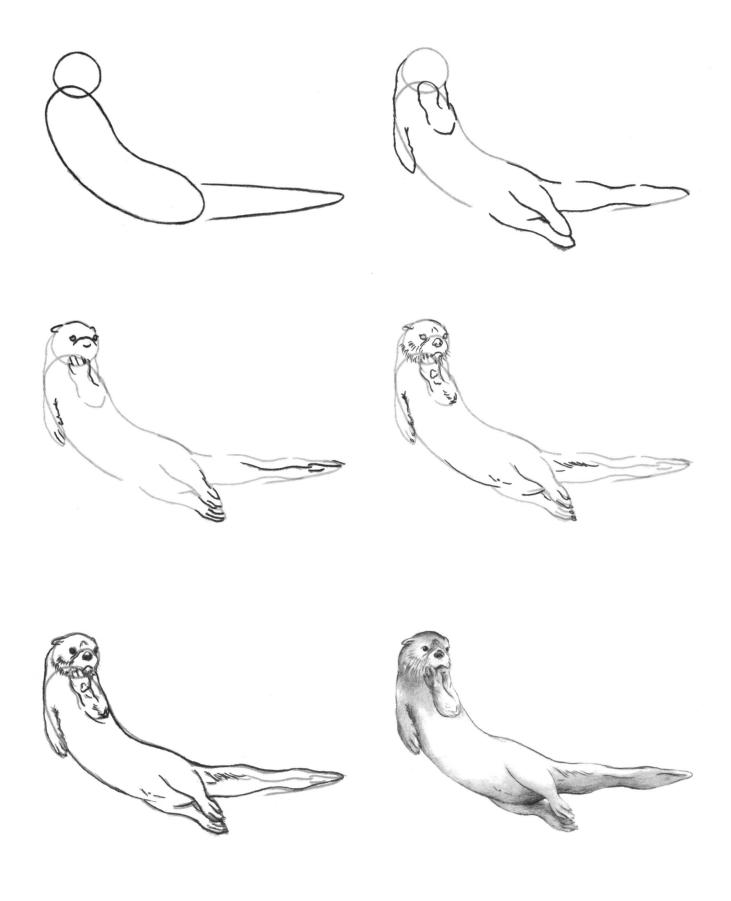

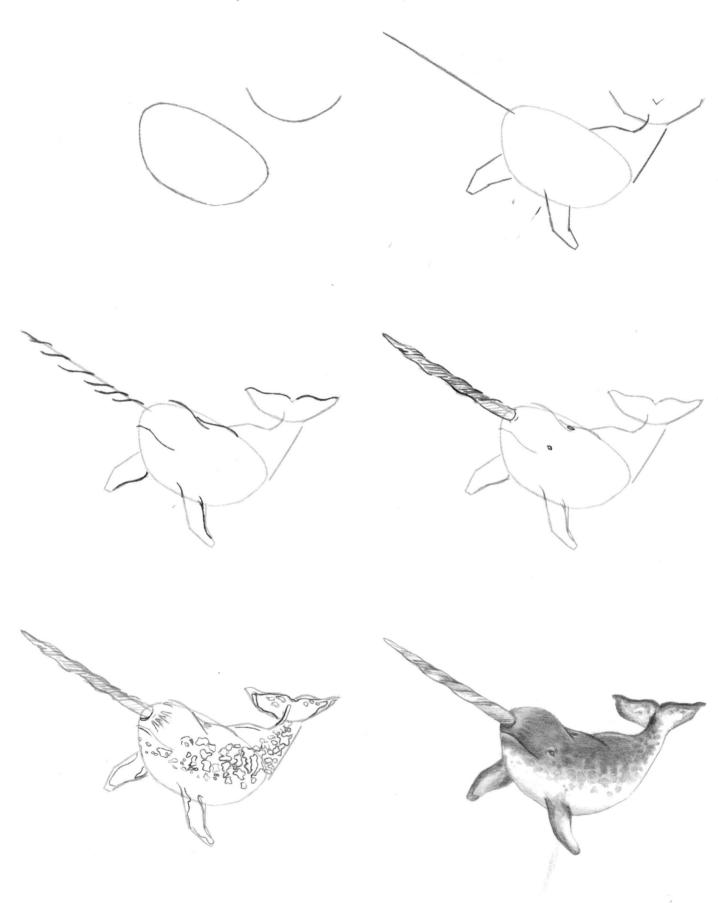

HUMPBACK WHALE

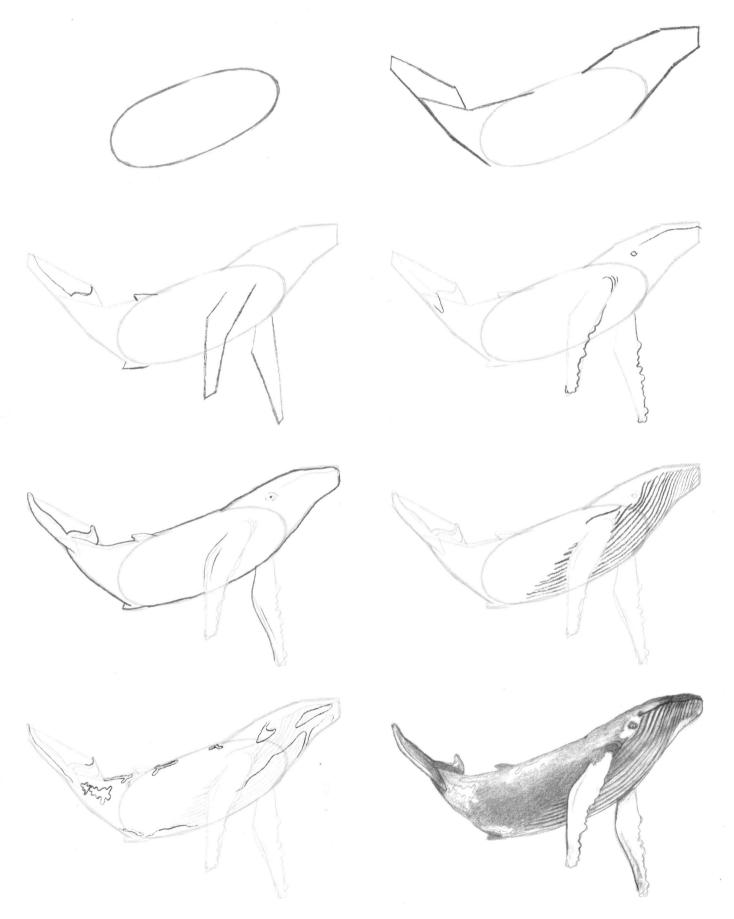

BOTTLENOSE DOLPHIN

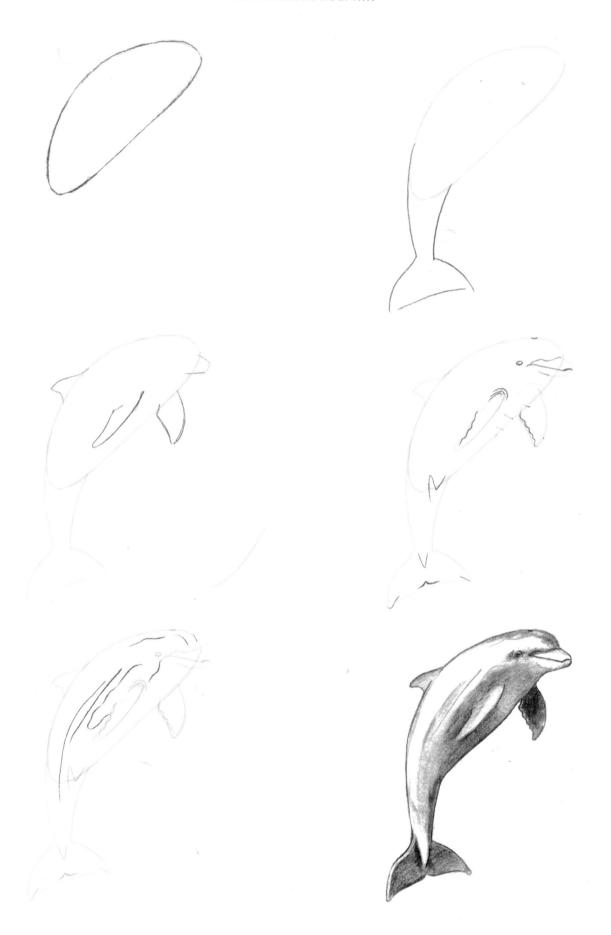

LEATHERBACK SEA TURTLE

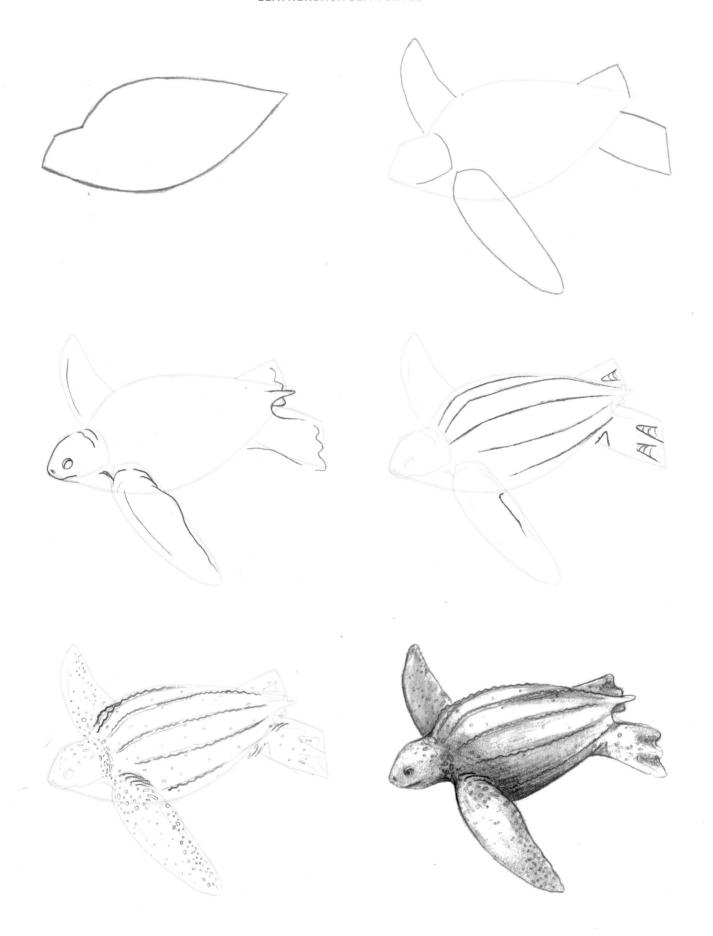

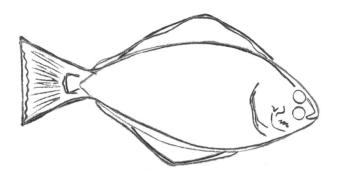

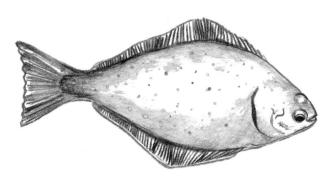

SOCKEYE SALMON

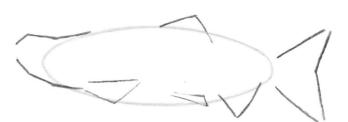

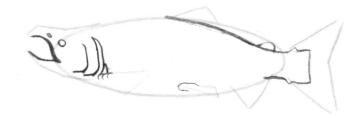

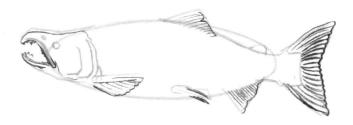

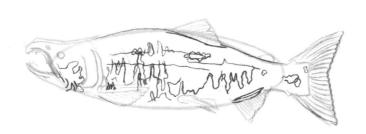

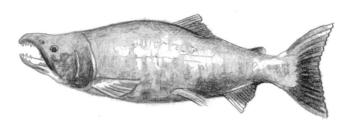

STRIPED SURGEONFISH

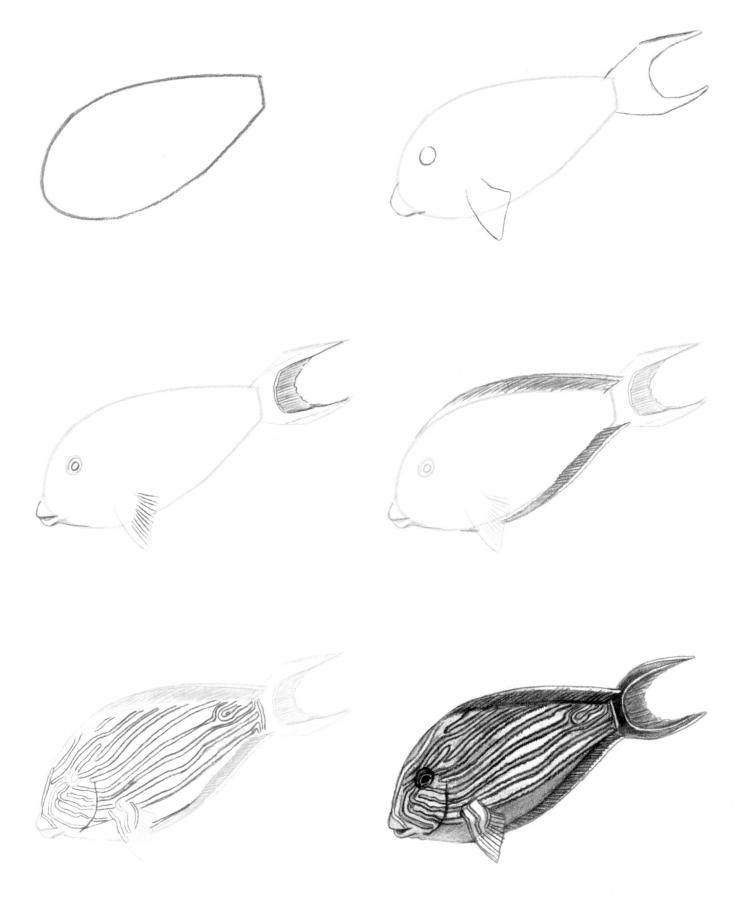

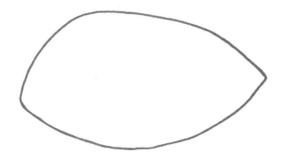

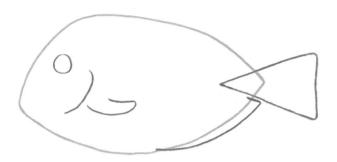

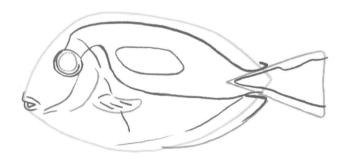

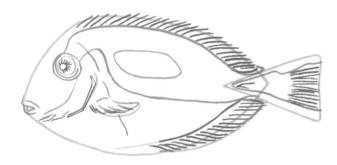

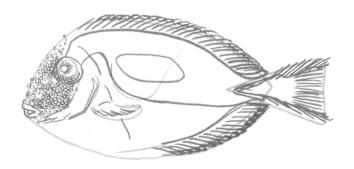

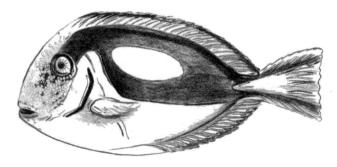

CLOWN TRIGGERFISH

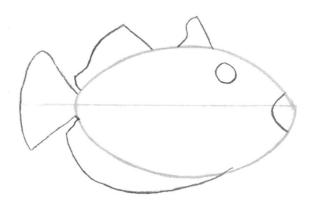

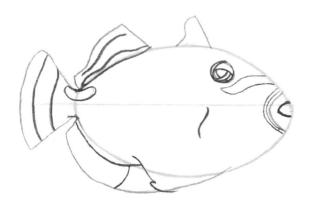

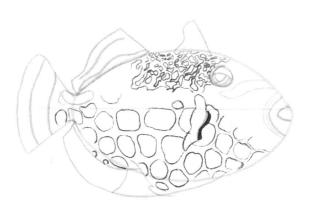

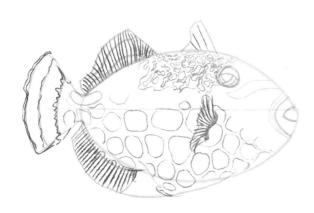

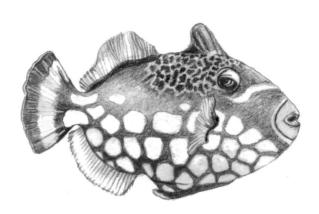

CLOWNFISH

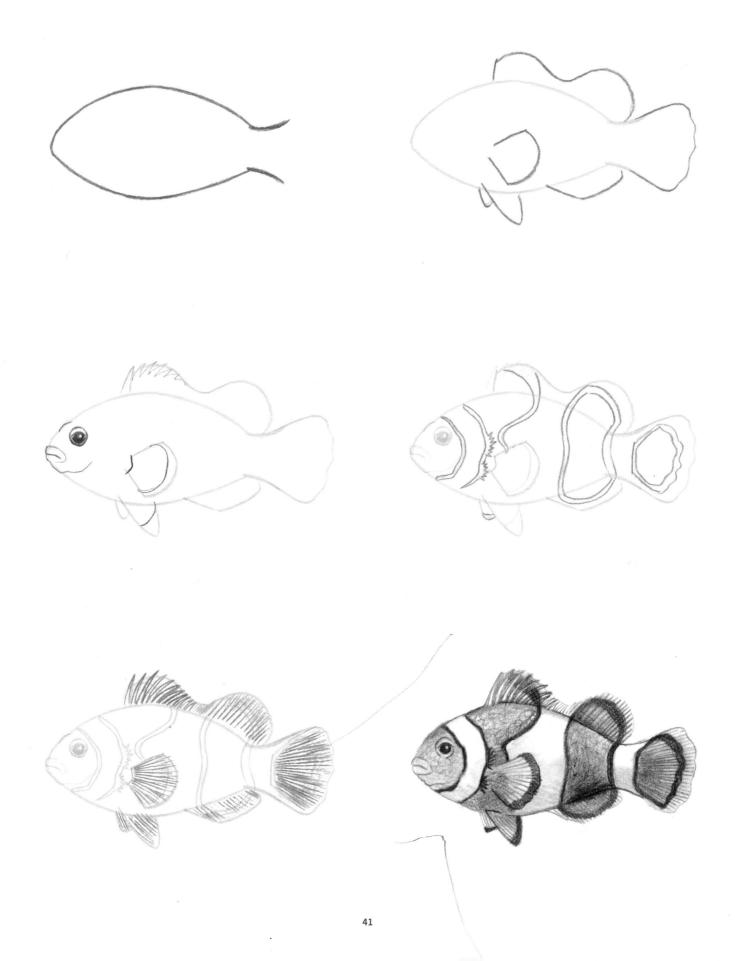

MOORISH IDOL

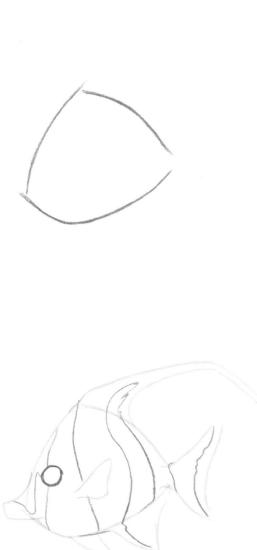

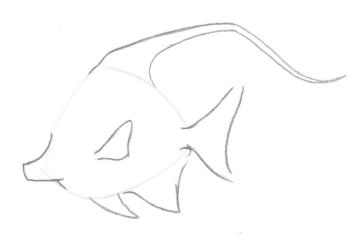

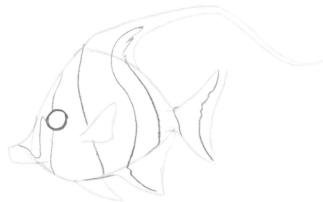

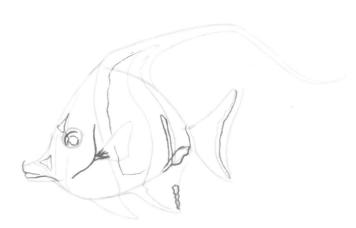

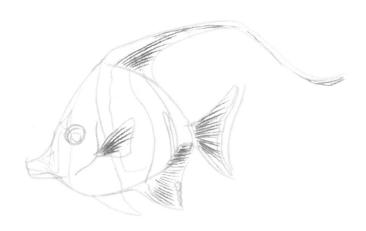

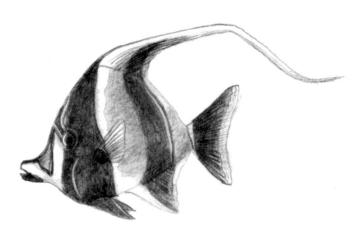

CARDINALFISH

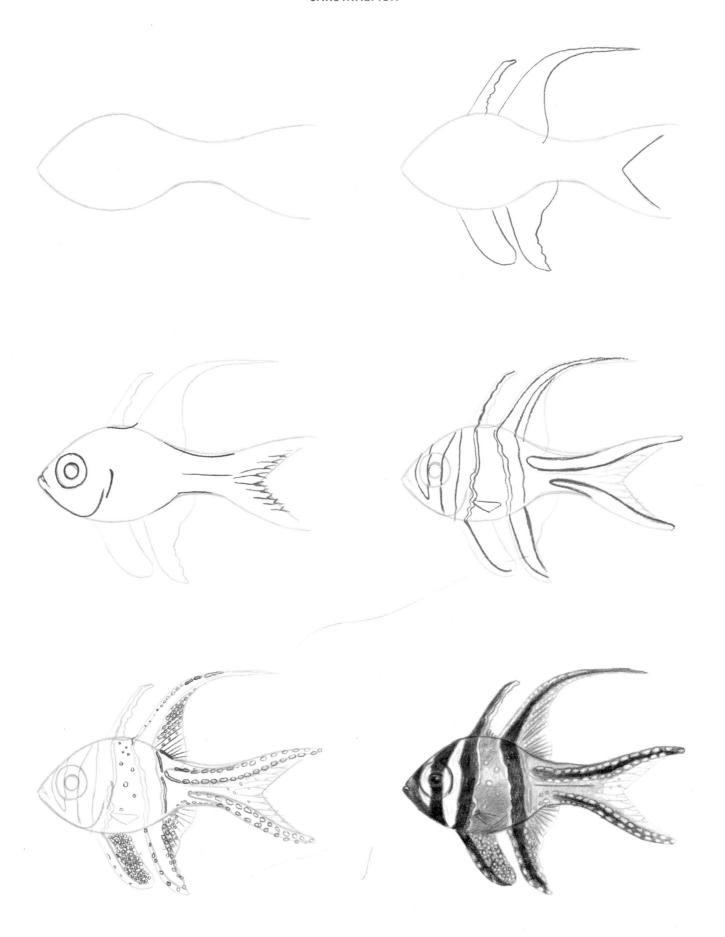

COPPERBAND BUTTERFLYFISH

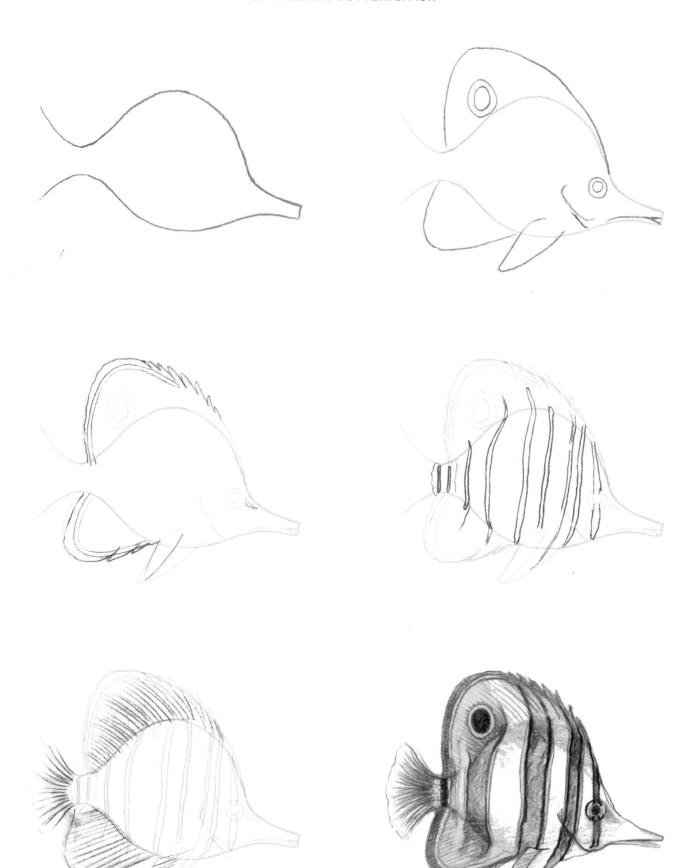

LIONFISH

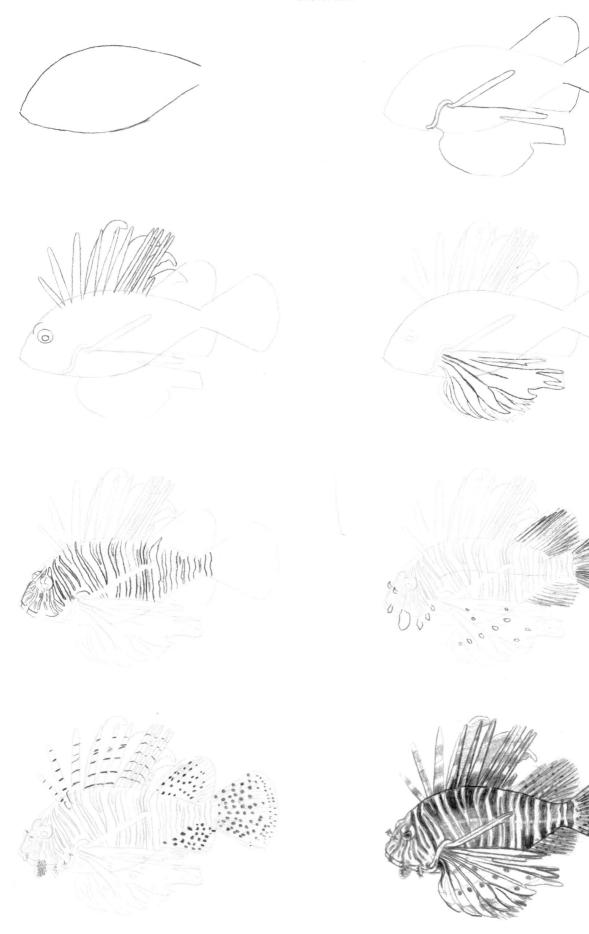

HANDFISH

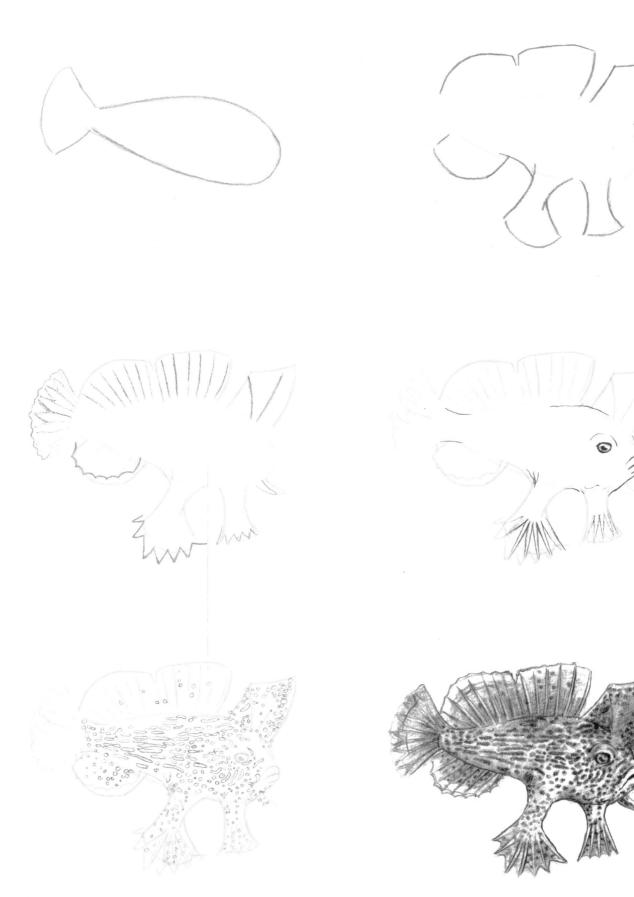

HAWAIIAN SQUIRRELFISH

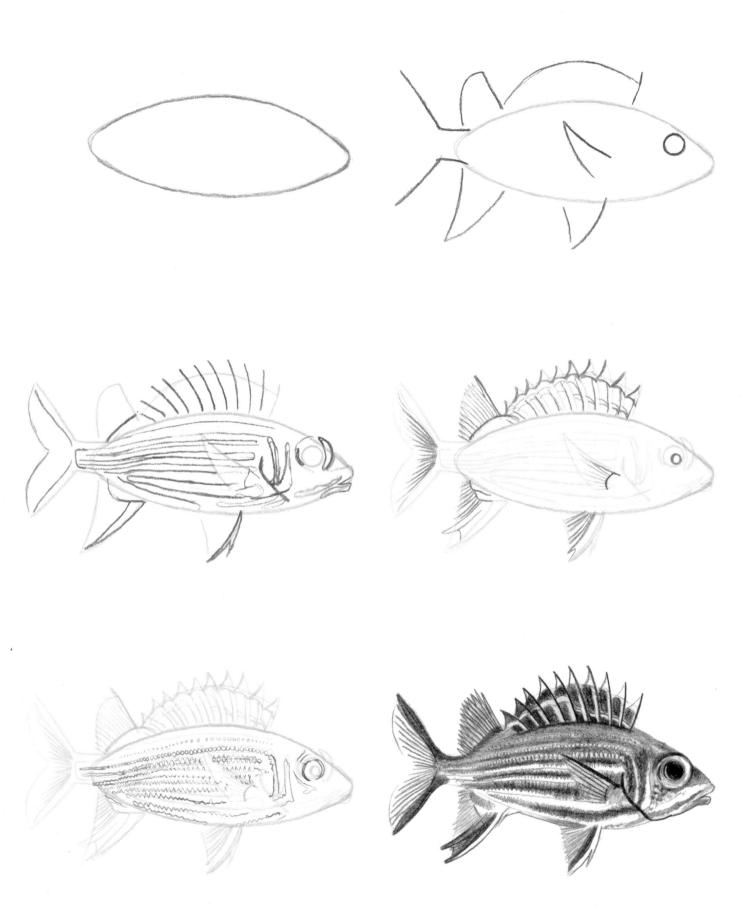

GOLIATH GROUPER

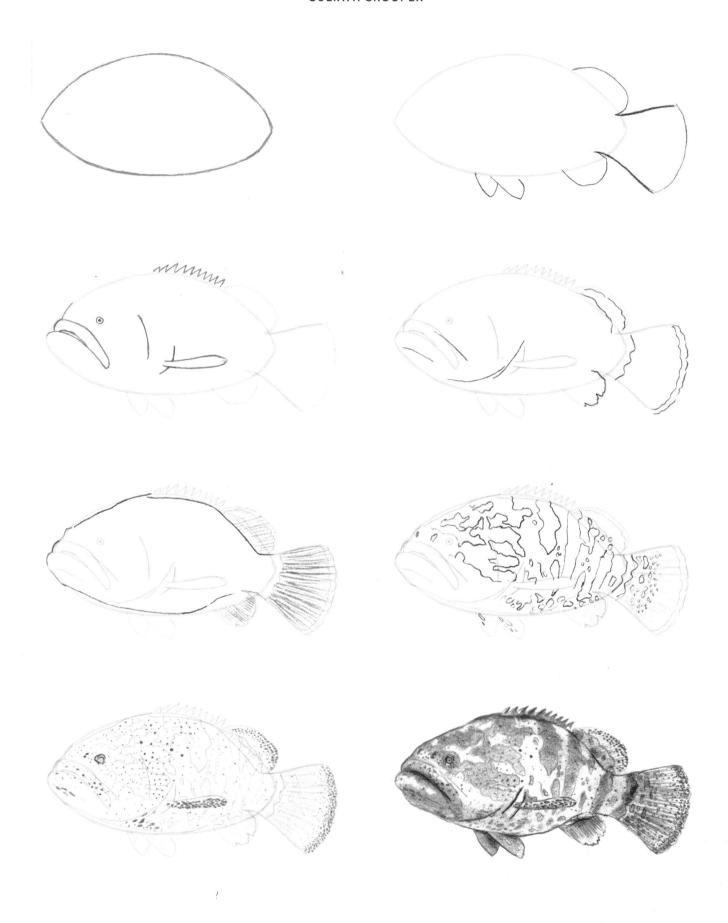

BALLOONFISH

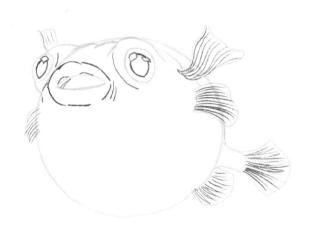

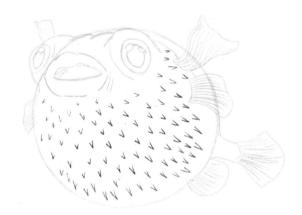

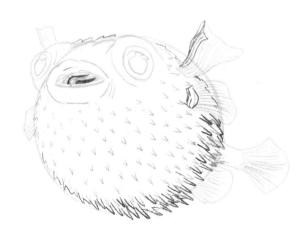

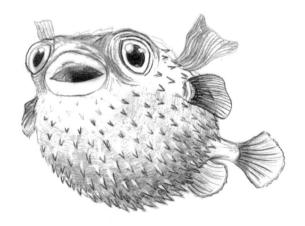

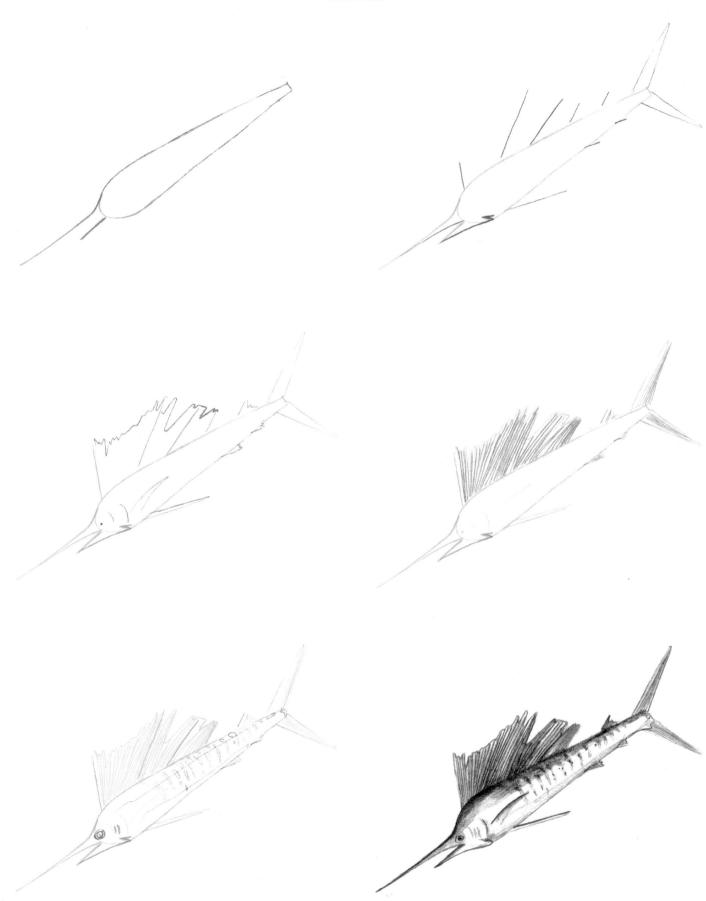

ANGLERFISH

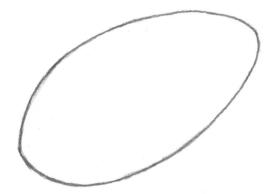

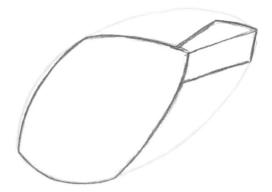

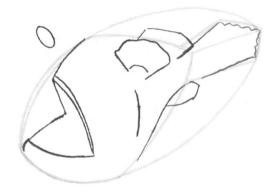

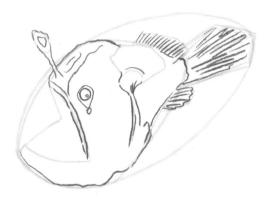

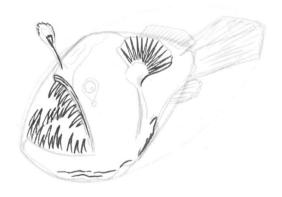

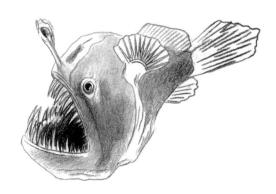

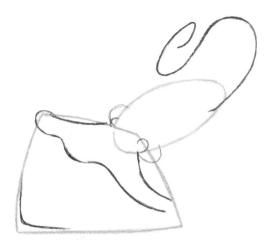

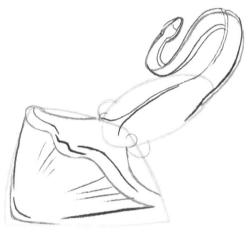

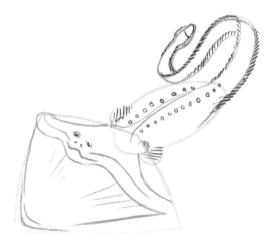

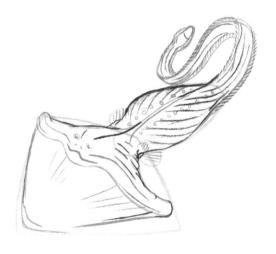

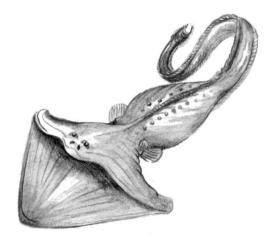

BASKING SHARK

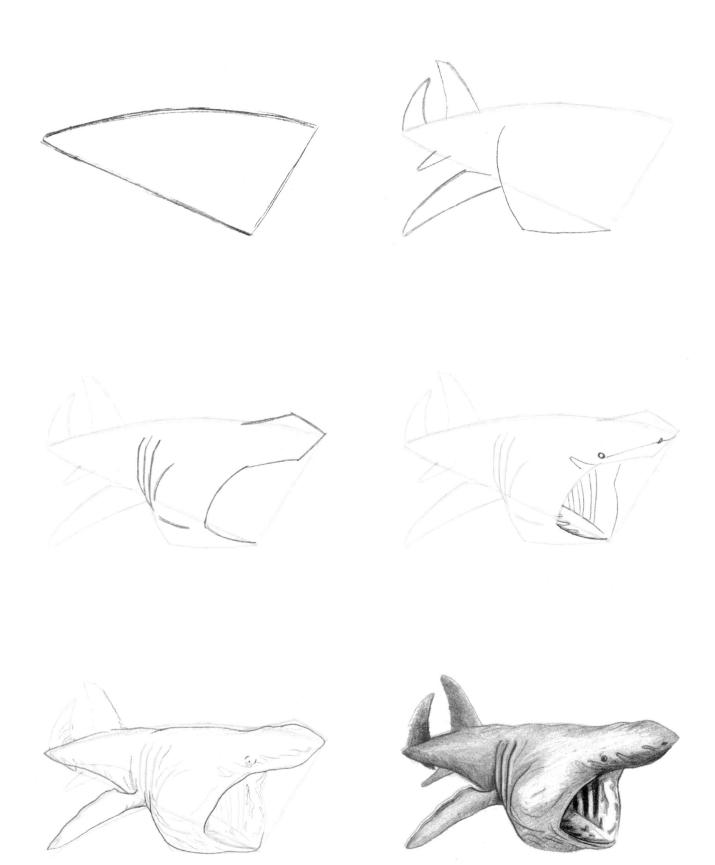

WHALE SHARK

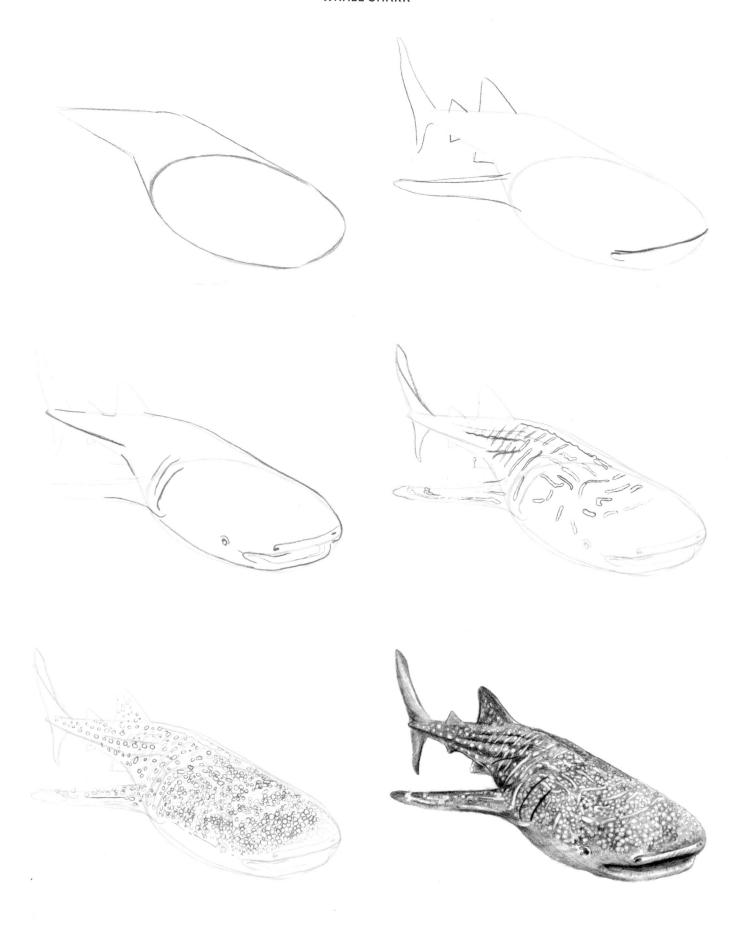

BLACKTIP REEF SHARK

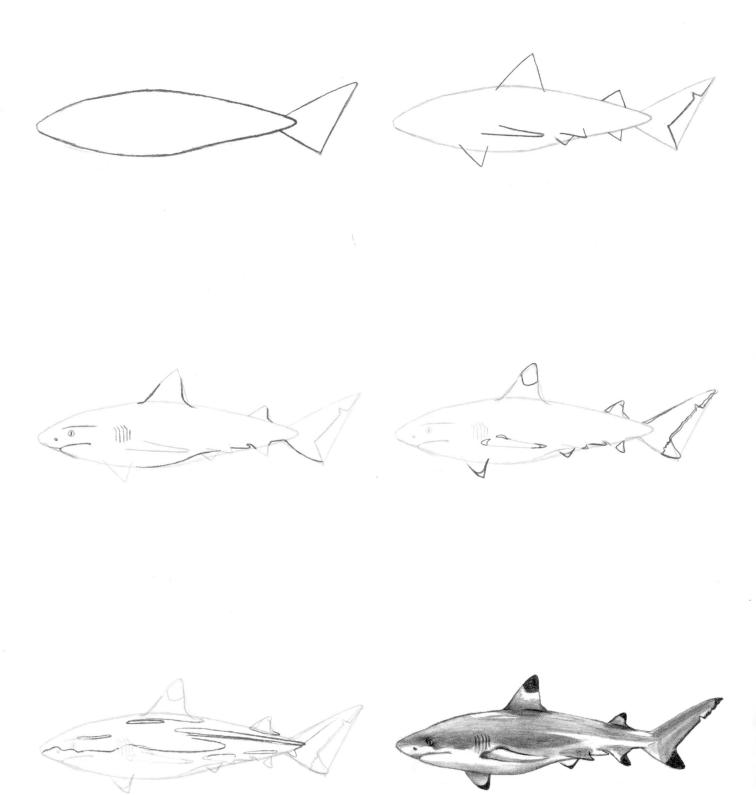

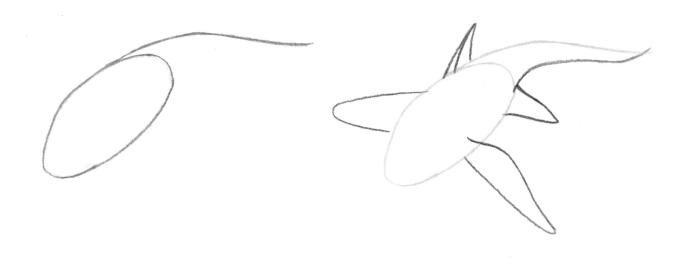

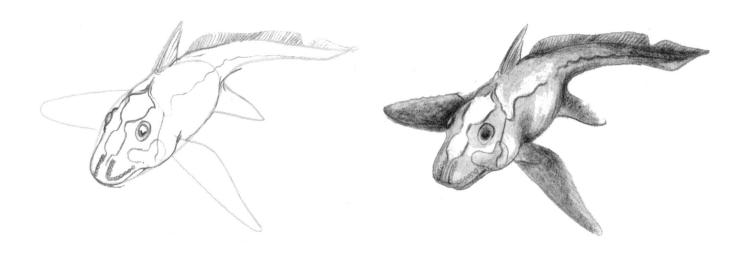

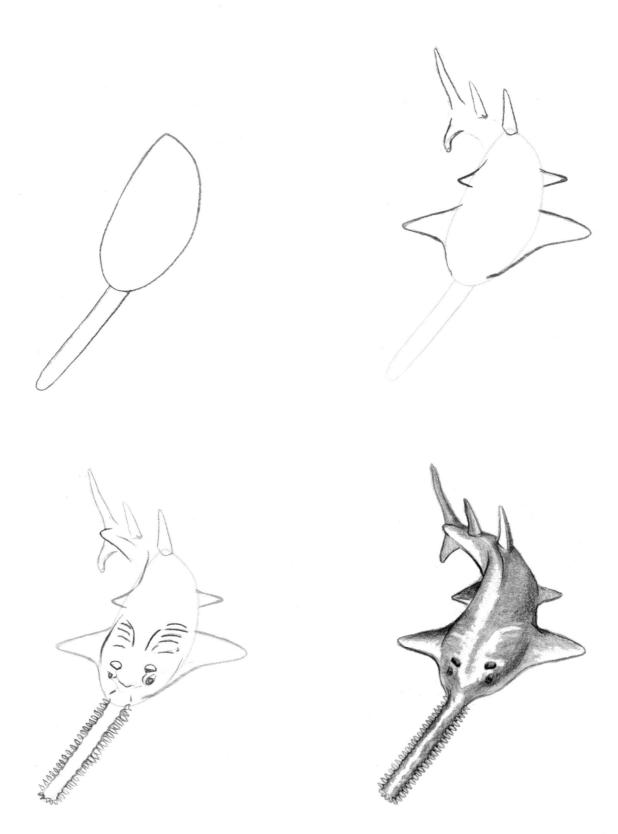

SOUTHERN STINGRAY

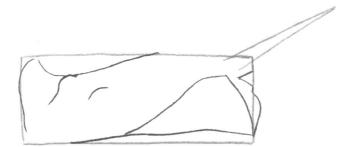

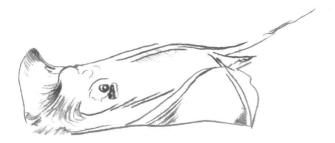

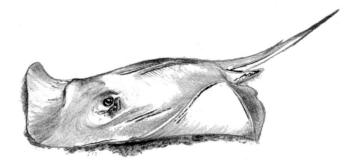

BLUE-RINGED OCTOPUS

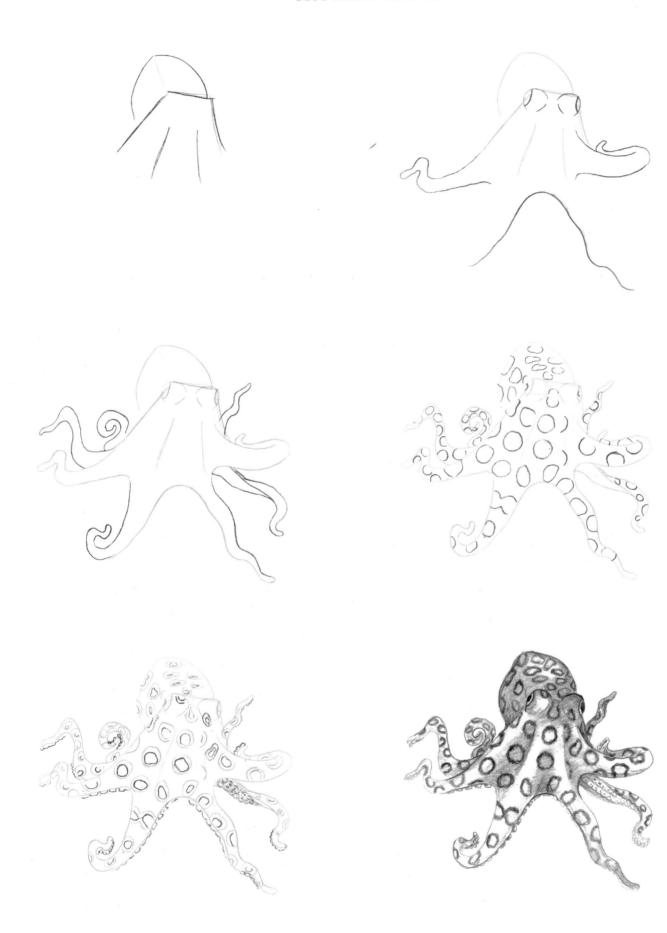

ABOUT THE AUTHOR AND ILLUSTRATOR

Lee J. Ames began his career at the Walt Disney Studios, working on films such as *Fantasia* and *Pinocchio*. He taught at the School of Visual Arts in Manhattan, and at Dowling College on Long Island, New York. An avid worker, Ames directed his own advertising agency, illustrated for several magazines, and illustrated approximately 150 books that range from picture books to postgraduate texts. He resided in Dix Hills, Long Island, with his wife, Jocelyn, until his death in June 2011.

Erin Harvey is an artist who works primarily in pencils, charcoals, oils, and pen and ink. She lives outside Atlanta with her husband, Ben, and their two children.

EXPERIENCE ALL THAT THE DRAW 50 SERIES HAS TO OFFER!

With this proven, step-by-step method, Lee J. Ames has taught millions how to draw everything from amphibians to automobiles. Now it's your turn! Pick up a pencil, get out some paper, and learn to draw everything under the sun with the Draw 50 series.

Also available:

- Draw 50 Airplanes, Aircraft, and Spacecraft
- Draw 50 Aliens
- Draw 50 Animals
- · Draw 50 Animal 'Toons
- Draw 50 Athletes
- Draw 50 Baby Animals
- Draw 50 Beasties
- Draw 50 Birds
- · Draw 50 Boats, Ships, Trucks, and Trains
- Draw 50 Buildings and Other Structures
- Draw 50 Cars, Trucks, and Motorcycles
- Draw 50 Cats
- Draw 50 Creepy Crawlies
- Draw 50 Dinosaurs and Other Prehistoric Animals
- · Draw 50 Dogs
- Draw 50 Endangered Animals
- Draw 50 Famous Cartoons
- · Draw 50 Flowers, Trees, and Other Plants
- Draw 50 Horses
- Draw 50 Magical Creatures
- Draw 50 Monsters
- · Draw 50 Outer Space
- Draw 50 People
- · Draw 50 Princesses
- · Draw 50 Sharks, Whales, and Other Sea Creatures
- Draw 50 Vehicles
- · Draw the Draw 50 Way

Copyright © 2017 by Jonathan D. Ames and Alison S. Efman Illustrations copyright © 2017 by Erin Harvey

All rights reserved.

Published in the United States by Watson-Guptill Publications, an imprint of the Crown Publishing Group, a division of Penguin Random House LLC, New York. www.crownpublishing.com www.watsonguptill.com

WATSON-GUPTILL and the WG and Horse designs are registered trademarks of Penguin Random House LLC

Library of Congress Cataloging-in-Publication Data

Names: Ames, Lee J., author. | Harvey, Erin.

Title: Draw 50 sea creatures: the step-by-step way to draw fish, sharks, mollusks, dolphins, and more / by Lee J. Ames with Erin Harvey.

Other titles: Draw fifty sea creatures

Description: California: Watson-Guptill, 2017.

Identifiers: LCCN 2017017754 |

Subjects: LCSH: Marine animals in art—Juvenile literature. | Drawing—Technique—Juvenile literature. | BISAC: ART / Techniques / Drawing. | ART / Study & Teaching. | ART / Subjects & Themes / Plants & Animals.

Classification: LCC NC781 .A445 2017 | DDC 743.6/7—dc23 LC record available at https://lccn.loc.gov/2017017754

Trade Paperback ISBN: 978-0-399-58017-8 eBook ISBN: 978-0-399-58018-5

Printed in the United States

Design by Chloe Rawlins

10987654321

First Edition